Postmark Paris

Postmark Paris

A LITTLE ALBUM OF MEMORIES

Leslie Jonath

CHRONICLE BOOKS

SAN FRANCISCO

Printed in Hong Kong.

Library of Congress Cataloging-in-Publication Data:
Jonath, Leslie, 1964-
 Postmark Paris : a little album of memories / Leslie Jonath.
 p. cm.
 ISBN 0-8118-0555-7
 1. Americans—Travel—France—Paris—Fiction. 2. Stamp collecting—France—
 Paris—Fiction. 3. Girls—France—Paris—Fiction. 4. Paris (France)—Fiction.
PS3560.04517P67 1995
818'.5403—dc20
[B] 94-15575
 CIP

Book and cover design: Gretchen Scoble
Calligraphy: Lilly Lee

Distributed in Canada by Raincoast Books,
8680 Cambie Street, Vancouver, B.C. V6P 6M9

10 9 8 7 6 5 4 3 2 1

Chronicle Books
275 Fifth Street
San Francisco, CA 94103

For Mom, Dad and Michael

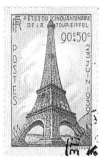

*T*his is the first stamp I bought in Paris, where my family lived for a year when I was nine. To me, the woman on the stamp was Annie Oakley. The black stick in her hand was a rifle, and the orange glow and white wisps behind her were fire and smoke.

I sent the stamp on a letter to my friend Jane in California. She had orange hair like Annie Oakley on the stamp. Jane was a wild girl. Only eleven, she had driven her mother's Maverick around the block. Later, when I figured out that the gun on the stamp was an old musical instrument called a lute, I was disappointed.

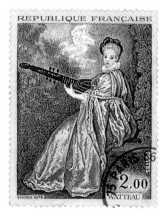

REPUBLIQUE FRANÇAISE

2,00

WATTEAU

GANDON 1973

Our apartment, on the thirteenth floor, looked over the slate rooftops of the city. It had a bright red bathroom and wide floor-to-ceiling windows.

My father and mother loved to look through binoculars at Notre-Dame, the Eiffel Tower, Montparnasse, and the bridges that arched over the Seine. My three-year-old brother, Michael, and I preferred to look down at the fish pond. When my parents weren't looking, we threw bread out the window, trying to feed the fish.

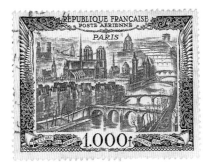

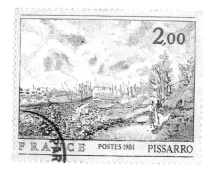

*M*y father was a tall man with a big handlebar mustache. He looked like Buffalo Bill but he was really a scientist. We had moved to Paris because he had a year-long position at the university. Once when I was little, I asked him why the sky was blue. "Light defracts at that wavelength through the nitrogen in the atmosphere," he said.

One day my father brought me several beautiful stamps from his mail at work. *Timbres* was the French word for stamps, he told me. Later, he gave me an orange stamp album with crackly, transparent pages. I spent a whole afternoon placing and rearranging my stamps in that album.

*O*ne afternoon my father took me to a dimly lit shop in our neighborhood. The room smelled of sweet pipe tobacco and was cluttered with dusty gray books, old maps, and piles of paper stacked to the ceiling like stalagmites. Inside a glass case, hundreds of tiny toy soldiers stood ready for battle. The shopkeeper, a short round man with white hair and glasses, sat behind his displays reading a book with a magnifying glass.

"Timbres?" said my father to the shopkeeper. The shopkeeper pulled a big, heavy book off a high shelf. Then he put on a pair of white gloves.

When he opened the book I saw hundreds of bright stamps—stamps from every country in the world, in all colors and shapes, full of fruit, flowers, and people. The whole world was in that book, I felt.

REPUBLIQUE FRANÇAISE

POSTES 1968

1.00

AUGUSTE RENOIR

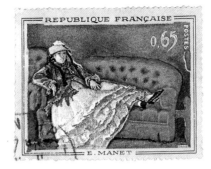

REPUBLIQUE FRANÇAISE

POSTES

0.65

E. MANET

*M*y father, the shopkeeper, and I paged through the book, looking at all the stamps. They were from everywhere, from Italy and Algeria and China. But the biggest and most beautiful stamps were the French ones.

My father and I selected one French stamp each. I chose the girl in the blue hat because I thought she looked like my mother when she was little in Brooklyn. My father chose a stamp of a pretty woman sitting on a blue couch.

"You'll look like that someday," he said.

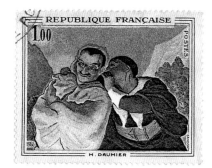

*O*ne Saturday morning my father and I went to the open-air stamp market off the Champs-Élysées. The street, shaded by chestnut trees, was lined with tables and easels displaying thousands of stamps. Behind the tables old men sat under big black umbrellas and played cards. We pushed through the crowd, in search of the best collections and prices. The stamp men whispered to one another as we walked by.

*N*ear the end of the market I found the largest display of big French stamps. Behind the table an old stamp man sat, his black beret tight on his huge bald head. I couldn't speak French yet, so I pointed to the stamp I wanted to see, lightly touching it.

"Attention!" the stamp man shouted. *"Ne touchez jamais avec les doigts."*

Later, when I asked my father what the stamp man had meant, he told me that you should never touch stamps with your fingers. I had noticed that all the stamp men wore gloves or handled the stamps with tweezers. But the next time we went to the stamp market, I avoided that stamp man's table. I didn't like him, even if he did have the best collection.

REPUBLIQUE FRANCAISE

1,00

ROGIER DE LA PASTURE (ROGER VAN DER WEYDEN) Pinx.

PHILIPPE LE BON

*f*rançois, our neighbor in the apartment building, was a pilot for Air France. A dashing man with bright blue eyes, he spoke English with a thick accent and waved his arms around when he couldn't think of a word.

François and his wife, Bernadette, had lived in Japan. Their apartment was filled with delicate Japanese prints and dolls in colorful embroidered silk. Going there was like a visit to Japan, my father said. When I told François I was collecting stamps, he gave me some Japanese ones with pictures of women in kimonos that were as beautiful as the things in his house.

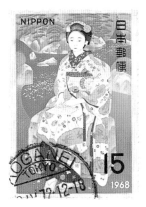

*O*ne evening François took us on a drive around Paris. All the monuments and fountains were lighted. We drove along the Seine, past a barge that floated under the Pont Neuf, past the Conciergerie where François said Marie Antoinette's head had been chopped off. We continued up the Champs-Élysées to the end, where we joined thousands of cars speeding around the Arc de Triomphe. We swerved in and out of the traffic looking for a way out. It seemed like we might be stuck circling forever. François shook his fist at a car to his left and shouted something at a car to his right.

"I love this," he said happily.

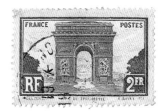

*f*rançois and Bernadette's eighteen-year-old daughter, Marie Françoise, had long honey-colored hair and spoke English very well. She wanted to be a stewardess so she could travel to California.

One night my parents went out, and Marie came over to stay with Michael and me. We made a blueberry tart and ate it while we watched "Wild, Wild West," dubbed in French, and practiced handstands in the living room. Marie gave Michael a plastic monkey named Coco, who wore a blue kimono and smiled like a clown. Michael loved Coco. After that he carried the doll with him everywhere, but I thought it was the ugliest thing I'd ever seen.

*C*eril, the son of our other neighbors, Yves and Colette, was a naughty little boy. He insisted on taking off his clothes and running around naked in our apartment. My mother chased him around and tried to get him to put his shorts back on, but he wouldn't.

He and Michael tore around the hallways of the building in their plastic cars until the other neighbors complained. At least Michael might learn French from Ceril, we hoped.

Sure enough, one day Michael came home and said, *"Voiture, bateau shlack!"*

The same day, Ceril was saying, "Car, boat, blam!"

Ceril was from Corsica. "Like Napoleon," my mother said.

*M*y father and I went often to the little shop with the stamps and toy soldiers.

My father got to know the owner of the shop. His name was Georges Monde.

"*Monde* also means 'world', " my father said.

My father told me that Georges Monde was a poet. One afternoon when we visited the shop, Georges read us poems from one of the books he had written. I loved to listen to him read, although I didn't understand any of it. I thought he was famous.

*G*eorges had most of the stamps I wanted in his collection—the big French tableaux stamps. His shop was just around the corner from our house, so I started walking there by myself. By then I'd been to the big stamp markets, and I knew the prices of the stamps. One afternoon I picked out one with a picture of a blue wizard holding a sword.

"Trois francs," I offered.

"Cinq francs," Georges said.

"Trois francs," I insisted.

He rolled his eyes. "You will ruin me," he said. He stuck to his price for a long time before I could talk him down, but I finally left with the stamp.

REPUBLIQUE FRANÇAISE

POSTES

1,00

EMAIL CHAMPLEVE LIMOUSIN XIIᵉ SIECLE

*A*nother time when I was in his shop, Georges told me about an artist he'd known when he was a little boy. The artist bought his groceries at the store Georges's parents owned. Once he didn't have enough money to pay his bill, and instead gave Georges's mother a small painting. After the artist left the shop, she left the painting in a corner on the floor near the potato bin. When a neighbor admired it, Georges's mother said, "It's no use to me. You take it."

"Now the painting is famous," Georges said. "It hangs in the museum. My mother pulls her hair out whenever she thinks of it."

One Sunday my mother took Michael and me to the market on the Rue Mouffetard. The produce stands overflowed with striped melons, purple plums, red tomatoes, and baskets of yellow flowers. The blue-aproned vendors yelled out prices as we passed their stalls. Dead chickens and rabbits hung upside down in the butcher shops.

It was so crowded and noisy that we didn't notice that Michael was missing. When we did, my mother ran back down the street frantically calling his name and pushing against the crowd. I looked in a shop that sold smelly cheeses and in the fish shop where we'd bought mussels. Finally I found Michael. He had his face pressed to a bakery window, and he was staring at the chocolate éclairs.

I rode the Métro to school for the first time one dark fall morning. The train traveled underground for a while, then emerged and rushed along on elevated tracks. Standing at the window, I watched the sun rise over the Seine. At Montparnasse the car suddenly became crowded. A businessman towered over me. His newspaper rested on my head.

As the train approached my stop, I got up and moved toward the door. When the door opened, the surging crowd pushed me off the train onto the platform. Suddenly I realized I had gotten off at the wrong stop. I reached for the handrails and struggled to get back on the train. "Let me back in!" I cried in English. A woman in a brown raincoat, somebody else's mother, grabbed my arm and pulled me back onto the train.

POSTES 1977

2,00

FRANCE

P. P. RUBENS 1577 - 1640

*M*y father had a friend from Russia named Edward, who brought me his letters. A thin man with big eyes, Edward was a physicist like my father. Together, Edward and I steamed stamps off the envelopes over a whistling tea kettle. We peeled them back carefully so they wouldn't tear.

One night Edward brought over a big white telescope. We set it up on the balcony and watched the bright moon rise over the city. Edward pointed the telescope at the moon and held me up to the lens. Looking through it, I could see the big craters and their dark blue shadows.

*T*hat night Edward gave me a painted wooden doll with smaller and smaller dolls inside it. The biggest doll was the Soviet Union; the others were Czechoslovakia, Bulgaria, and Romania, he said. My parents laughed, but I didn't understand this. Edward and my parents drank vodka and ate dill pickles until late that night. From my bed, I heard more laughter.

Edward had invited us to come visit him in Russia, but we couldn't get visas because my father's work was secret. "It might even be dangerous for Edward," my father said.

So Edward went back to Russia, and we never heard from him again.

ČESKOSLOVENSKO

KOUZELNÍK S KARTAMI

60h **FRANTIŠEK TICHÝ** 1890 1961

NÁRODNÍ GALERIE V PRAZE

i didn't know what my father did at work. Until he told me he was a scientist, I thought he sold shoes. Then he took me to his lab, and we filled up balloons with helium.

One morning on my way to the Métro a strange man approached me. "What does your father do?" he said in English.

I stared straight ahead and kept walking. He repeated his question. "I'm not allowed to speak to strangers," I said and ran into the station.

When I told my parents about the man, they said they did not know him. My father said I had done the right thing. His work seemed more mysterious than ever.

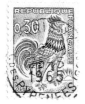

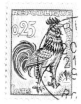

*T*he first school I went to in Paris was near the Eiffel Tower. The École Bilingue stood three stories tall and had a big blue door. My first day I was late, and my class was on the third floor. I clomped up the staircase in my red rubber boots, and the second-floor class glared at me.

In class we spoke both French and English. We sang a French song about barnyard animals to practice our pronunciation. In English, the teacher told us, roosters said "Cocka-doodle-doo," but in French they said *"Cookerie-coo."* One of the British kids sang the song perfectly. I was too embarrassed to sing because I was afraid my pronunciation was bad. I didn't care what roosters had to say anyway.

*a*t recess the kids played marbles in the Champ-de-Mars, a long rectangular park near the school. The marbles came in many colors and sizes, from small brown root beers to large green-and-white swirls. We drew a ring in the dirt and tried to throw the marbles in the center and at then at one another. The winner got to keep all the marbles.

I collected blue marbles for a while, but I kept finding them in my brother's mouth. Finally, I just gave him all the marbles. He loved them. When they weren't in his mouth, he carried them around in his fists.

I preferred my stamps. They were my world. To me, the stamps were tiny pieces of something large and beautiful.

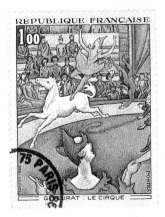

REPUBLIQUE FRANÇAISE

1,00

75 PARIS

POSTES

G. SEURAT : LE CIRQUE

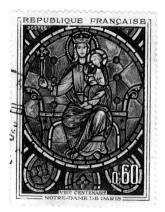

*O*ne morning a week before Christmas we walked to Notre-Dame. We entered the cathedral during the rehearsal for midnight mass. The light streamed through the stained-glass windows and illuminated the stone floors.

Except for a large woman who sat in the pew next to ours, we were alone in the huge church. She watched Michael crawl around under the seats and smiled at me when I went to retrieve him. Then, after a while, the woman surprised us by standing up and joining the musicians. She sang, and her voice filled the cathedral. I felt that she was singing just to me.

*S*ince I lived so far away from my school, I didn't know any kids in the neighborhood. In the afternoons I read fairy tales and sat on the barstool at our kitchen counter, spinning around in circles.

One time I dressed Michael and Ceril up like characters out of my fairy tales, and we made up a play about a prince, a magic frog, and a princess who wanted to be a race-car driver. Then we paraded around the apartment.

"Vive la France!" shouted Ceril.

*O*ne Sunday I went to the neighborhood square called René le Gall. A large canopy of chestnut trees lined the path in the garden, and small pink roses covered four blue arbors. There I sat and fed old baguettes to the birds. When I looked up, I noticed a small dark-haired girl watching me. I smiled at her, offered her some of the bread, and said, *"Oiseaux,"* pointing to the birds. She took a few pieces, and together we threw the last of the crumbs.

The girl pointed to herself and said, *"Française."* Then she pointed to me and asked, *"Toi?"*

"Leslie," I said. I was happy to meet a girl my own age.

*J*ust then another girl walked up. The two of them spoke quickly to each other in French. I stood there smiling. Then Française pointed to her friend. *"Française,"* she said.

Two girls with the same name, I thought.

"Bonjour, Française!" I said to the friend. The two girls giggled.

They were strange, I decided. I waved good-bye and went home.

REPUBLIQUE FRANÇAISE

1,00 POSTES

P. GAUGUIN

I didn't like the École Bilingue, and my parents didn't like me taking the Métro by myself, so in the spring I transferred to the neighborhood school. On my first day my mother walked me to a peach building with a French flag. Inside classes had begun, and the sound of my mother's high heels reverberated as we walked down the long hallway.

We knocked on a frosted glass door. A tall, blond woman opened the door. *"Allo, oui?"* she said, then bending down to me, asked, *"Comment t'appelles-tu?"* I understood what she said, but was too terrified to answer. "What is your name?" she said in English.

"Leslie," I said, barely breathing. She turned to the class and asked the children to welcome me. *"Bonjour, Leslie!"* the class shouted.

*A*s I walked into the room, I saw two girls waving wildly from the back of the class. I was thrilled. The teacher gave me a seat near them.

"Bonjour Française et Française!" I said.

"Sylvie," the dark-haired girl said, *"je m'appelle Sylvie."* She pointed to her friend. *"Anne,"* she said. Finally I understood the word *Française,* which simply meant they were French.

*t*hat first month in the French school I didn't understand very much. Once when the class took an eye test I had to read the chart in French and forgot the word for the letter *y*. I was convinced they would mistakenly decide that I needed glasses. The next day the teacher, Madame Bailleux, called my name. The class applauded, but I started to cry. "I don't need glasses," I said.

"Non, non," said Madame. I had received the top score on a math test.

CENT 2.20

E N A I
R E
L' E DE
E CO
LE

ESTIENNE

RÉPUBLIQUE·FRANÇAISE

*S*ylvie and Anne sang a song by Jacques Brel, a famous French singer. I knew the song and Jacques Brel because my mother played his records at home. His music was so beautiful that it made her sad, my mother had said. I had seen her cry once in the middle of the song called *"Je t'aime."*

I told Sylvie and Anne that I liked Sacha, the Czech boy who sat next to me in class. Sacha had green eyes, blond hair, and freckles.

*S*acha lived in my neighborhood. Our mothers had become friends, and we sometimes saw each other on weekends. I could see into the courtyard of his house from our kitchen window. Sometimes he played with a soccer ball down there.

In Georges's shop I bought a toy man with a plastic parachute. I took it home and waited for Sacha to come out. Then I threw the toy out the window, hoping it would land in the middle of his soccer game. Unfortunately the parachute didn't work, and the little man fell in the fish pond. When I asked Sacha about it, he said he hadn't seen the parachutist. He liked the idea, though, and asked if we could try it again together.

The next day I brought two baseball gloves to his house and we played catch. After that, Sacha and I played catch almost every day. But in school we ignored each other.

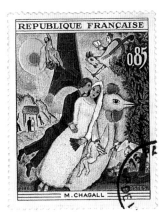

*A*t school Madame Bailleux helped me practice my French vocabulary. One afternoon, while the class worked on a reading lesson, she called me up to her desk and asked me to name all the vegetables I knew in French.

"Concombres, carottes, radis," I said.

I heard Sylvie's voice from the back of the room, *"Poivrons!"*

"Tomates!" called Anne.

"Aubergines!" yelled Sacha.

Madame Bailleux told everyone to be quiet and get back to work.

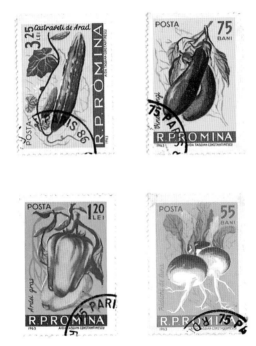

*M*ichael's nursery school, the Ecole Maternelle, was just behind the Ecole Corvisart. At home he sang French songs we couldn't understand. He also learned how to eat cooked peas with a knife.

Once when I peered through the back fence of my school, I saw Michael playing with his friends. He was making funny faces and giggling as he chatted away. I watched him for a long time and made a face at him, but he didn't see me.

*O*ne day after school Sylvie, Anne, and I ran to the bakery to buy *pain au chocolat.* The bakery lady had red frizzy hair, and her white apron was smudged with chocolate and strawberries.

A group of teenagers wearing gold cardboard crowns came in laughing. Sylvie said the crowns were part of *la Fête des Rois*—the Festival of the Kings. The bakers hid beans in almond cakes called *galettes.* The person who got the bean in each cake became king for the day.

When I got home I found that my mother had bought an almond cake for us. Michael got the bean in our cake. We didn't have a toy crown, so we put my father's baseball hat on him instead.

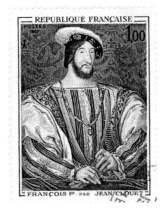

*O*n the way to Georges Monde's shop I passed the long ivy-covered walls of the French tapestry factory, Le Manufacture des Gobelins. I thought Gobelins sounded like goblins, and I imagined creepy little beasts locked inside.

But one afternoon my mother and I ventured through the factory gates. Huge ornate tapestries hung in the entryway, and in the gray stone workshops rows of enormous mahogany looms almost touched the ceiling. The tapestries had been created in the same way for three hundred years, my mother said.

We stopped to admire a tapestry that was less than half finished. Behind the screen of threads, the weaver worked, his fingertips occasionally poking out. He did not glance up or speak to us. Dwarfed by the loom, he did look a little like a goblin, I thought.

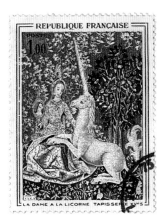

REPUBLIQUE FRANÇAISE

1.00 POSTES

CRATÈRE DE VIX

*M*y family went to the horse races at the Bois de Boulogne one Saturday. We sat in the bleachers near the stables and watched the jockeys brush down their shiny horses. My mother and I chose our favorites on the track. At the end of each race she always pointed to the winning horse and said, "I knew that horse would win."

"Why don't you bet if you know the winning horse?" I asked.

"It's more fun this way," she said.

*T*hat same night we went to the ballet at the Opera house. In the balcony, we sat in red velvet chairs and stared up at the painted ceilings—full of dancing animals and blue violinists—until the dance began. The dancers jumped and twirled on stage, but I kept staring at the ceiling. In the dark, I could still see the outline of a bride and groom floating over the chandelier.

*O*nce when we vacationed in the Dordogne, my mother went for a walk in the woods. Later, she came back crying and ran into my father's arms. She'd found an old cemetery, she said, and had stopped in front of a weedy, forgotten grave. When she looked at the tombstone, she was shocked to read her own name there.

After she told us the story, she stopped crying, and then started to laugh. My father held her for a long time. I didn't know what she found so funny.

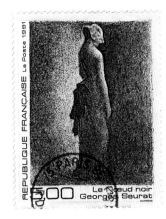

REPUBLIQUE FRANÇAISE La Poste 1991

5'00

Le Nœud noir
Georges Seurat

DURRENS

*F*or my birthday, my parents took me to a fancy restaurant. We ate *pâté de foie gras,* oysters, and smoked salmon. Then my father ordered a plate of *escargot*—snails. The snails tasted of garlic and butter, and I liked them even if they looked disgusting. For dessert I had a *Poire Belle Helene,* which was a chocolate-covered pear with vanilla ice cream.

After that I didn't feel so good.

REPUBLIQUE FRANÇAISE

2.00
POSTES

*O*ne afternoon my family visited the Jardin des Plantes. My parents went to the fossil gallery, and I took Michael for a walk in the little garden zoo. We liked the antelopes and the bison because they reminded us of "Wild, Wild West."

In the corner of the garden a little monkey sat and squalled, sticking his hand out of his cage. Michael got carried away and fed the monkey a salami sandwich. Suddenly, the monkey grabbed Michael by the hair; Michael began to scream and flail about. I reached between the bars and squeezed the monkey's tiny hairy hand until he shrieked and let go. I picked Michael up and carried him, crying, to my parents. They didn't believe the story.

REPUBLIQUE FRANÇAISE

POSTES

1,00

GROTTE PREHISTORIQUE DE LASCAUX

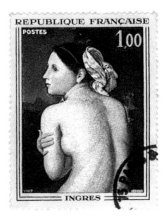

*O*ne sunny day in May my class took the train to Deauville, a little beach town in Normandy. Hundreds of blue-and-white striped umbrellas covered the beach. We took off our shoes and dug holes in the fine gray sand. Then everyone decided to go swimming. Sylvie and Anne and the other girls didn't wear their tops. I just went wading with my pants rolled up. "It's too cold to swim," I said shyly.

*T*he Louvre was so big that you couldn't see it in one day. When my class went there, we walked for hours and hours. We started on the first floor and walked from the treasures of Egypt past the Roman mosaics to the French paintings.

I was starting to get tired when I looked up and saw a painting of a man I recognized from a stamp. I didn't know his name, but he seemed familiar, like an old friend.

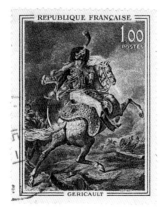

REPUBLIQUE FRANÇAISE

1.00
POSTES

GERICAULT

*A*s the days grew long and warm, my family picnicked. In the Parisian parks we sat in the green metal chairs, and ate bread, cheese, salami, and peaches. Sometimes we went to the Luxembourg Gardens to see the tulips and poppies and to take Michael on pony rides. Other afternoons we went to gardens of the Tuileries by the Louvre, where children floated toy sailboats on the fountain and the cafés sold *gaufres*— giant waffles covered with whipped cream.

*b*ut my favorite place to picnic was on the banks of the Marne River, just outside of Paris. There we ate tiny fried fish, called *fritures,* and paddled on the river in rowboats.

One hot afternoon Michael and I discovered a wild blackberry bush. The berries were sour, but we ate them until our lips were dark purple. After that all four of us fell asleep in the shade.

*A*t the end of the school year, the class gave me a going-away party. Sacha presented me with two French books, and Sylvie and Anne gave me a bouquet of flowers. Before I left, the whole class lined up *pour faire les bisoux*—to kiss me good-bye on the cheek.

O

*O*n August everyone went away. Sacha took the train to visit his grandmother in Czechoslovakia; François, Bernadette, and Marie flew off to Japan; Ceril went to Corsica; and Sylvie and Anne drove to the south with their families. Paris was warm and quiet.

I spent my last month in Paris walking around the empty city with my family. There were no cars on the streets, and the days were slow and relaxed. It seemed to me the only other people in town were tourists who asked us for directions in English.

Then one afternoon at the park I met a French boy I hadn't seen before. I told him I was going home to California. I was lying, he said. I was French just like him. I said a few words in English to prove to him that I was American.

"N'importe quoi," he said, which meant that I was just talking nonsense to try to fool him.

One evening my family walked up the Rue Mouffetard to the Place Contrescarpe. In the center of the square, under a small red canopy strung with white lights, a young woman sang an old French song while two old men played accordion music. Couples danced, children sang, and people in cafés watched.

My father and mother waltzed. I swung Michael around in circles. We danced until late that night.

REPUBLIQUE FRANCAISE

2,00

POSTES 1973

BEQUET

CHARLES LE BRUN

*T*he last time I went to see Georges Monde, I found him sitting behind his typewriter smoking his pipe. When I shut the door behind me, the draft blew a few loose papers onto the floor.

"What are you writing?" I asked.

"A poem," he said.

"Will you write to me when I go back to California?" I asked.

"If you give me the stamps," he said.

At home there were no stamp men like Georges Monde.

*T*hen we went home. Back in California my grandfather gave me his big old stamp book. Bound in brown paper, it contained hundreds of valuable stamps from all over—from places I didn't recognize and countries that no longer existed.

It felt odd to receive someone else's collection. I thanked my grandfather but kept his collection on a shelf separate from my own. My little album was full of the people and places I had known that year. Opening it, I could always visit them again.

acknowledgements

I wish to thank my friends, my family, and my colleagues at Chronicle Books who have been so wonderfully supportive of this book; especially to Annie Barrows for her insightful editing, Gretchen Scoble for her lovely design and Nion McEvoy for his encouragement. Thanks also to Elise Cannon, Karen Silver, Sharon Silva, and most of all to Jim Paul.

COLOPHON

This book is set in Garamond Three on a Macintosh computer.
Claude Garamond (1840–1561) based his original type,
Romain de l'Université, on designs by Aldus Manutius.
First specimens are found in books printed in
Paris around 1532.

The hand lettering is done by Lilly Lee in Berkeley, California.
Book design and composition by Gretchen Scoble.
It is printed and bound in Hong Kong.